Faithful Friends

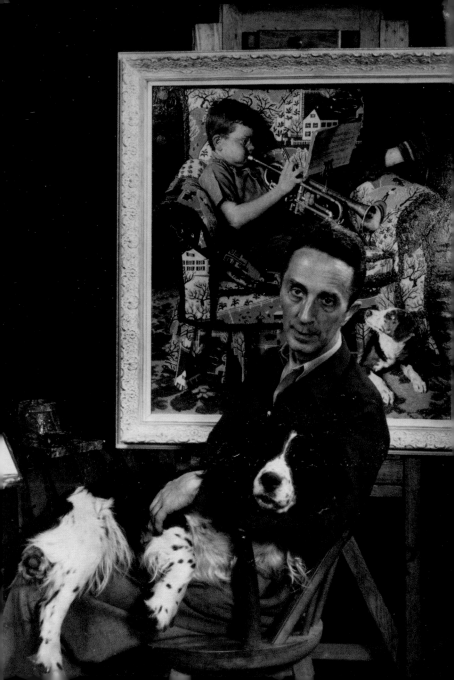

Faithful Friends

Norman Rockwell and His Dogs

Margaret Rockwell

Abbeville Press Publishers
New York London

FRONT COVER: *Boy with Puppies*, 1922. See page 88.

BACK COVER: *Your Faithful Friend*, c. 1925. See page 15.

PAGE 2: Rockwell and his dog Butch pose for a publicity shot in front of *Boy Practicing Trumpet*, which was published on the cover of the *Saturday Evening Post* on November 18, 1950.

PAGE 78: Reference photo for *Christmas Dance*, 1950. See page 106.

PAGE 128: Rockwell takes an afternoon nap with two friends in this photo by Clemens Kalischer.

Editor: David Fabricant
Designer: Misha Beletsky
Layout: Julia Sedykh
Production manager: Louise Kurtz

First edition
10 9 8 7 6 5 4 3 2 1

ISBN 978-0-7892-1441-6

Library of Congress Cataloging-in-Publication Data available upon request

For bulk and premium sales and for text adoption procedures, write to Customer Service Manager, Abbeville Press, 655 Third Avenue, New York, NY 10017, or call 1-800-ARTBOOK.

Visit Abbeville Press online at www.abbeville.com.

Contents

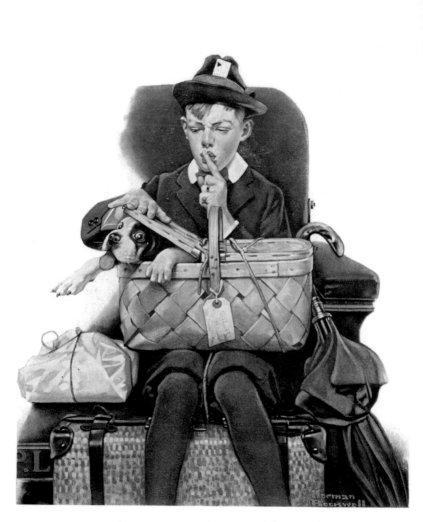

Boy with Dog in Picnic Basket, cover of the *Saturday
Evening Post* (May 15, 1920). The boy is trying to
keep his dog a secret as he rides the train, but the
pup clearly wants to escape its hiding place.

Faithful Friends

There were dogs in Norman Rockwell's house and dogs in Norman Rockwell's studio. He had dogs as pets and dogs as models. Often his pets became his models, appearing on his famous covers for the *Saturday Evening Post* and other magazines. Raleigh, Butch, and finally Pitter were all Rockwell family pets who appeared in his paintings and his drawings. He also used strays, his neighbors' dogs, dogs from the pound, and even the famous Hollywood star Lassie as models. Rockwell knew the importance of man's best friend in his life and in his work.

The Early Years in New Rochelle

At the beginning of his career, Rockwell illustrated children's magazines almost exclusively, and he needed boys and dogs to pose for his paintings. In his autobiography, *My Adventures as an Illustrator*, he

describes how he tracked down his models in New Rochelle, New York, where he lived and painted from 1913 to 1939. He says that if he could find a boy's mother, then she would be easily convinced to make her son pose for the artist; however, getting dogs to pose was a completely different matter:

> The dog was more complicated. First I had to find him; then I had to follow him about until I learned where he lived. Once I chased a dog all afternoon through vacant lots, over fences, down and up gullies, through briars, burrs, and nettles. He was a perfect mutt, the best I've ever seen—black patch of fur around one eye, woebegone, lanky, and rough. But he was tricky and escaped through a back yard crisscrossed by clotheslines hung with clammy sheets and shirts.
>
> After I had discovered where a dog lived I had to persuade his owner to let me take him up to my studio. Some of the owners thought I was a vivisectionist, others that I was the dogcatcher or just crazy. One old lady who had seen me chasing dogs about the neighborhood accused me of an inveterate and perverse taste for dog meat.

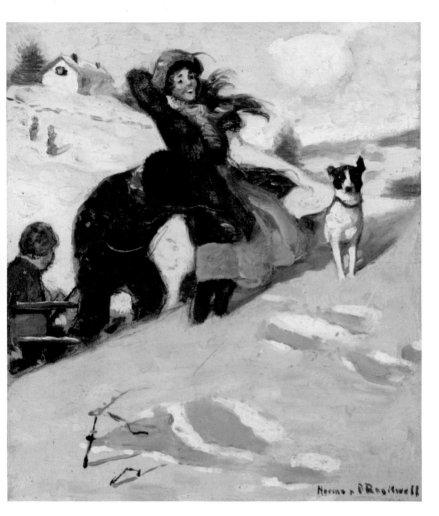

Girl in Snow with Dog, cover of *St. Nicholas* magazine
(January 1916). Rockwell painted this cover at the begin-
ning of his career, when his signature included his middle
initial. The dog looks alert and ready to play in the snow.

But finding the dog and the boy was nothing to posing them. You take a young mutt who's been reared on rats and garbage. *There's* exuberance and all-around *joie de vivre* for you. I'd set him up on the model stand, pushing him down on his haunches. He'd sit quietly for a few minutes, staring at me. Then he'd catch sight of his tail out of the corner of his eye and determine *he'd* put a stop to that impudent wagging before long; then it would be a flea behind his ear; then he'd take exception to the way I was holding my brushes and prance about the model stand, barking. . . .

But an old dog was the worst, one who'd been in and out of fights and garbage pails for eight or nine years, flop-eared, mangy, and resolute. He'd plop down on the model stand, growling every time I approached. I kept a sack of bones in the studio, but a bone was no help with an old dog—only made him worse. He'd snatch the bone and retreat under one of the sinks in the studio. Then he'd lie under there gnawing at the bone and snarling.

Still, I had to have dogs. The editor of the old *Life*, John Ames Mitchell, once told me that

the most popular subject for a magazine cover was a beautiful woman, the second most popular a kid, and the third a dog. Later on when I was doing *Post* covers I'd receive letters from readers saying, "I love that little boy, but, oh, that *dog*—with those human, beseeching eyes."

Rockwell regularly featured flop-eared dogs, with a black patch over the eye, in his early canvases. In 1917 and 1918, he painted a series of covers for *Country Gentleman* featuring city slicker Reginald's adventures with his country cousins and their dog Patsy, a sweet mongrel with the characteristic black patch around the eye. The mischievous

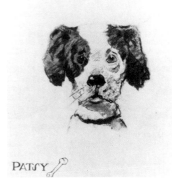

Patsy, illustration for *Country Gentleman* (August 25, 1917). Here is the quintessential flop-eared dog with black patches that Rockwell enjoyed depicting early in his career. From a series of sketches introducing the characters in Rockwell's Cousin Reginald covers for *Country Gentleman*.

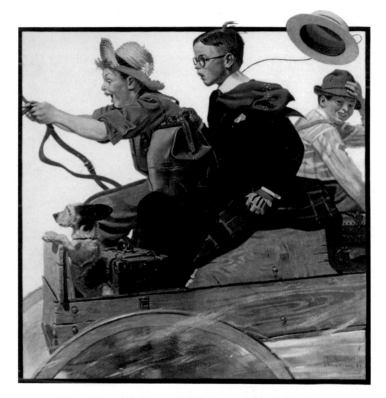

Cousin Reginald Goes to the Country, cover of *Country Gentleman* (August 25, 1917). Patsy rides in the front of the cart with her ears blowing in the wind as Cousin Reginald is introduced to country life.

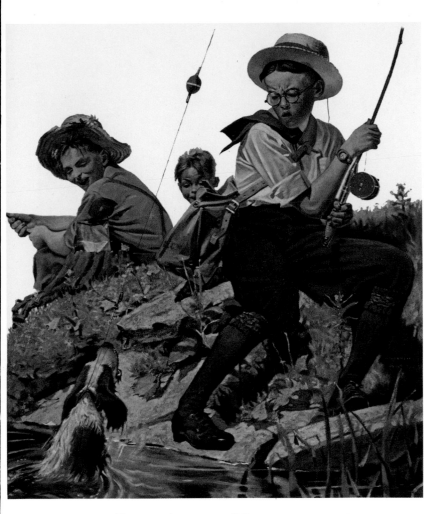

Cousin Reginald Goes Fishing, cover of *Country Gentleman* (October 6, 1917). Cousin Reginald tries to fish and only catches Patsy the dog.

children love to make fun of the prissy Cousin
Reginald as he is introduced to country pastimes like
swimming and sledding. Patsy, the dog, is both an
observer and a participant in the children's antics.

Rockwell used similar-looking pups in early
works to represent the close bond that exists
between a boy and his dog. In a painting of two boys
who have overindulged in pipe tobacco, the dog
reaches a compassionate paw through the fence
to express his concern for the boys' condition.
And then the artist shows how the canine compas-
sion is returned when a boy administers medicine
to his sick companion or ties a bandage around an
injured paw. Rockwell paints boys and their dogs
reveling in the freedom of the fishing pond and
the swimming hole—but sometimes the pup gets
carried away and steals the boy's pants! In other
works, the dog, a companion at play, represents the
good times that must be set aside when a boy pur-
sues his education or perhaps a little romance.

The spotted dog was also a source of amusement
and self-reflection for Rockwell. Throughout his
life, starting in the mid-1920s, Rockwell represented
himself in letters to friends as a black-and-white dog
with a tin can tied to his tail. For Rockwell, the tin

can represented the ever-present deadlines that he
always tried to outrun but would never succeed
in shaking off.

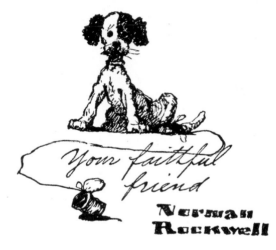

Your Faithful Friend, c. 1925. Rockwell first drew this dog,
with a patch over its eye and a tin can tied to its tail, in the
1920s. He used it throughout his career when signing let-
ters to friends and giving autographs to strangers; he also
sketched it at the dinner table to amuse his grandchildren.

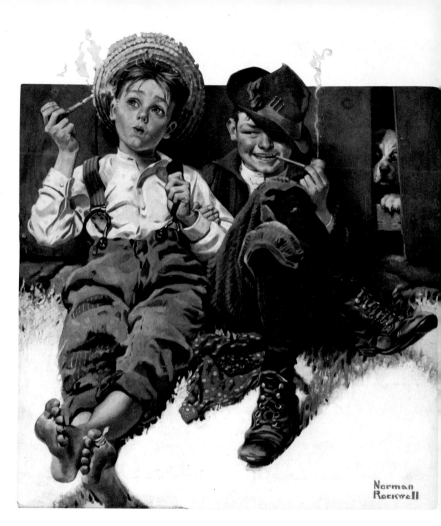

. . . But Wait til Next Week!, cover of *Country Gentleman* (May 8, 1920). In the first of this pair of covers, the dog watches from behind the fence as the boys try to smoke pipes.

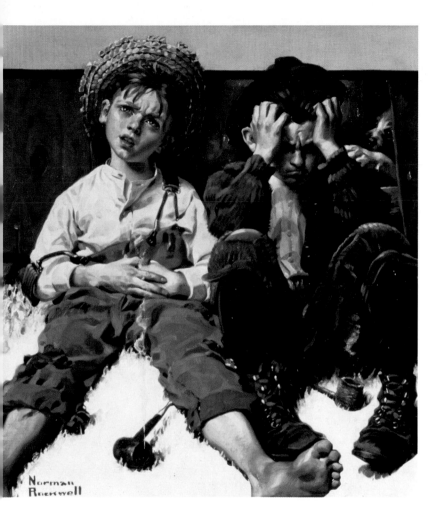

Retribution!, cover of *Country Gentleman* (May 15, 1920). In the second, he extends a paw to comfort one of the boys as they suffer the effects of the tobacco.

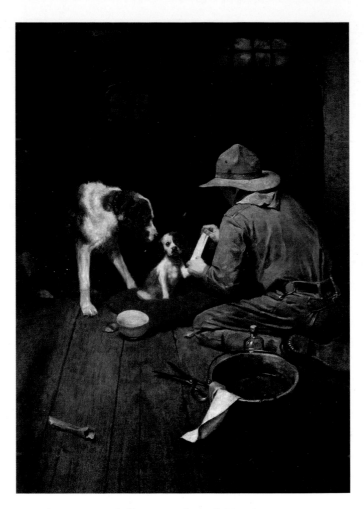

A Scout Is Kind, illustration for *Red Cross Magazine* (November 1918). A Boy Scout bandages a puppy's injured paw while its mother watches with concern.

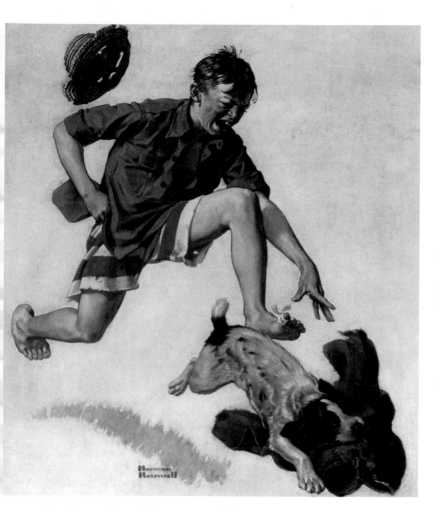

Boy Chasing Dog with Pants, cover of the
Saturday Evening Post (August 9, 1919). This
scamp of a dog has stolen the boy's pants!

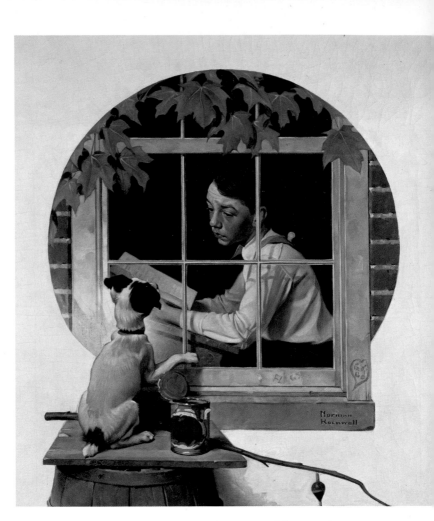

Schoolboy Gazing out Window, cover of the *Saturday Evening Post* (June 10, 1922). The spotted dog taps on the window of the schoolhouse to get the boy's attention. The tin of worms and fishing pole make it clear where they'd both rather be.

Could the spotted mongrel Rockwell painted in those early years be Lambert, whom the artist called one of the best models he ever had? "Lambert was the thoughtful type. I'd place him in position on the stand and he'd just sit there with his head cocked to one side, thinking, hour after hour. . . . The only thing he wasn't thoughtful about was cats. When he saw one he lit out after it crash, bang."

Rockwell's favorite boy models in New Rochelle, Billy and Eddie, knew about Lambert's inability to control himself around cats, so, of course, they smuggled a cat into the studio. According to the artist, "The cat and Lambert had been around the room four times—over the sinks, under the easel, through a sack of frames—before I realized what had happened. I yelled at Billy and Eddie but they were rolling on the floor with laughter. Finally the cat climbed the easel. Lambert tried to follow but couldn't make it, so a stalemate was reached: Lambert at the foot of the easel, leaping and barking; the cat at the top, hissing and spitting."

Rockwell found inspiration for the dogs he painted not only in children's everyday lives but also under the big top. In 1918 and throughout the 1920s, Rockwell painted circus dogs for the

covers of the *Literary Digest, Life* magazine and the *Saturday Evening Post.* The dogs on these covers wear pointed hats and ruffles around their necks. Some lie sleeping beside the clown; one rests his head on a clown's knee and looks sympathetically at a young runaway; another watches a puppy learn to balance on a ball; and still another keeps the audience waiting while the ringmaster bandages his injured paw. Clearly Norman Rockwell loved the circus, and his enthusiasm for its performers would be passed on to his sons.

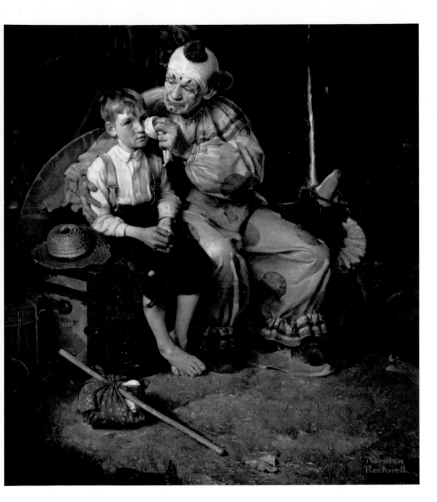

The Runaway, cover of *Life* magazine (June 1, 1922).
A black poodle, wearing a circus hat and a matching
ruffle, rests its head on the clown's lap and looks
at the runaway with great sympathy.

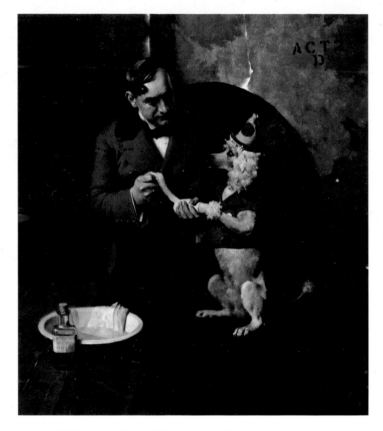

While the Audience Waits, cover of *Literary Digest* (October 28, 1922). A performing poodle gets some medical attention for his paw from the ringmaster.

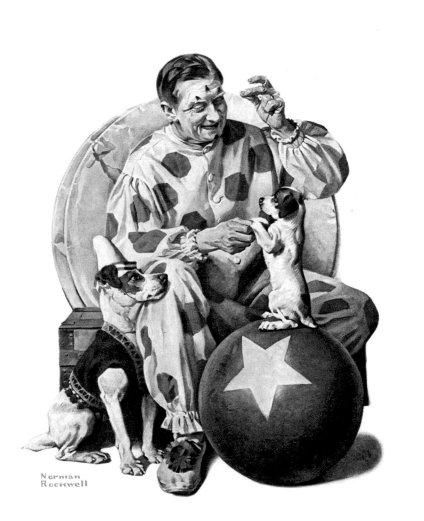

Clown and Dog, cover of the *Saturday Evening Post* (May 26, 1923). An experienced canine performer gives his full attention to a puppy learning to balance on a ball.

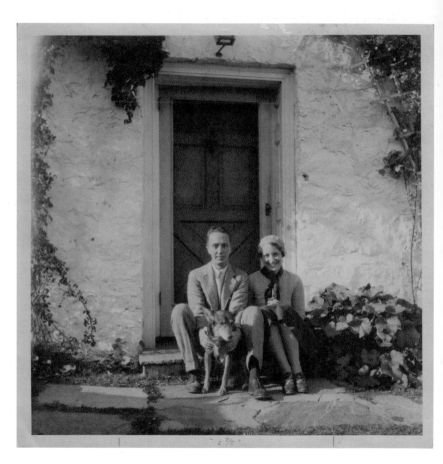

Newlyweds Norman and Mary Rockwell pose
with Raleigh the German shepherd outside their
home on Lord Kitchener Road in New Rochelle.

Raleigh the German Shepherd

The artist's biographers write of the dogs he had as
pets. He and his first wife Irene invited a German
shepherd into their household in 1926. They named
him Raleigh. This was when Rockwell's fame was
beginning to grow and fans were starting to seek
him out in New Rochelle. Raleigh helped the art-
ist feel more secure, accompanying him to and
from the studio every day. The bond between the
dog and his master was strong, and when Rockwell
traveled to Europe in 1929 without his wife, or
his dog, Raleigh became despondent. Perhaps
Rockwell was reflecting on his regrets about leav-
ing his pet behind when he painted a dog sitting
patiently beside his owner's luggage with an R
around his neck—the R might have been for Raleigh,
or maybe Rockwell—in a 1929 *Post* cover, *Boy with
Two Dogs.* Norman and Irene divorced in January
1930, and he married Mary Barstow in California
later that spring. In a photograph of the newly-
weds in front of their home on Lord Kitchener
Road in New Rochelle, Raleigh appears with them.

Raleigh did eventually travel across the Atlantic in
1932, when Norman, Mary, and their six-month-old

28

son Jarvis moved to Paris for eight months. When they returned to New Rochelle, Raleigh made it into family photographs. He looks very comfortable posing for a snapshot with Rockwell's two young sons, Jarvis and Tom. Raleigh would be the model for a *Saturday Evening Post* cover published in November 1935, entitled *Man Hiking with Dog*. He would also

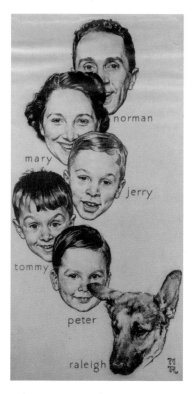

Rockwell drew this portrait of his whole family, including Raleigh, in Arlington, Vermont, c. 1940. It was used on a Christmas card sent to friends and family.

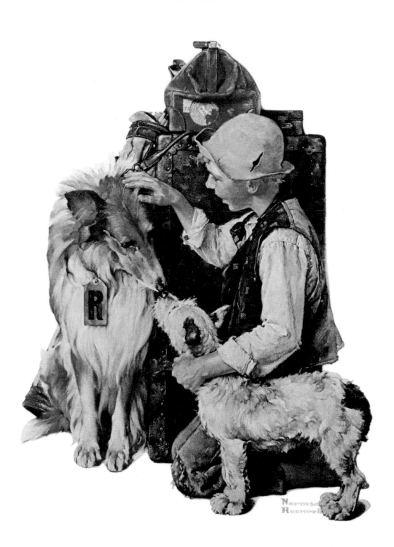

Boy with Two Dogs, cover of the *Saturday Evening Post* (September 28, 1929). The "R" around the collie's neck may refer to Rockwell's own dog, Raleigh, whom he had left behind when he traveled to Europe.

appear in a family portrait: Rockwell drew Raleigh, with one ear flopped over, along with all three of his sons, Mary, and himself in 1940. The portrait was completed after they had moved from New Rochelle to Arlington, Vermont. It was reported that Raleigh had to be put to sleep in the spring of 1943, after suffering from smoke inhalation when fire destroyed Rockwell's first Vermont studio.

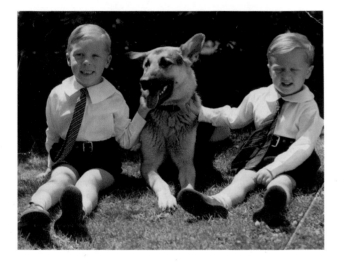

Rockwell's sons Jarvis and Tom with Raleigh.

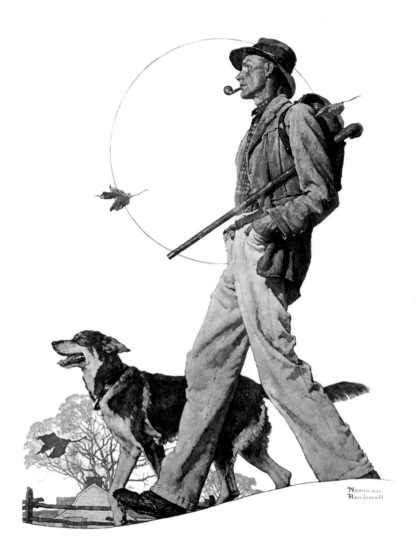

Man Hiking with Dog, cover of the *Saturday Evening Post* (November 16, 1935). Raleigh modeled for the dog in this painting.

Photographing the Canine Model

In New Rochelle, Rockwell would have to persuade
his canine models to hold the pose, sometimes for
hours at a time, while he painted them at the easel.
But by the time he and his family moved to Vermont
in 1939, the artist had started to use photographs
to capture the pose of models both animal and
human. Rockwell would direct his models to take
the poses he wanted from them, while a photogra-
pher stood by to snap the shutter and capture the

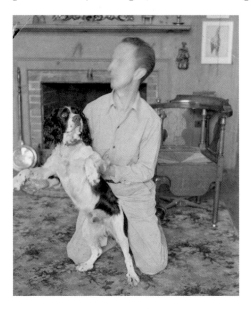

Rockwell poses his springer spaniel Butch
in his West Arlington, Vermont, studio.

image. Sometimes Rockwell would have to position a
dog manually; he would gently push down on the base
of the dog's skull to get the animal to relax and stop
resisting the pose. It didn't hurt the animal and would
allow the photographer to get the shot once the artist
jerked his hand away from the dog.

In his book *Rockwell on Rockwell*, the artist writes that

> obtaining good photographs of animals for use
> in pictures is quite a test of your photography
> or, in my case, my photographer. It takes much
> kindness and patience to handle animal mod-
> els but the effort is worthwhile because they are
> often important elements in story-telling pic-
> tures. The person taking the photographs must
> be extremely quick and ingenious because an
> animal may assume the pose you want for only
> a split second and you must be ready to snap
> the photograph at that unpredictable moment.
>
> I hold the animal where I hope he will assume
> the desired pose and my photographer focuses
> on him. Then I try to induce the model to take
> the desired pose. When he does I yell at the pho-
> tographer to shoot. Sometimes the result is a
> blurred picture but other times I am lucky.

Rockwell goes on to advise aspiring artists to "handle your animal models with kindness and never become impatient with them when taking photographs."

In a reference photo for *Fixing a Flat*, which appeared on the cover of the *Post* in 1946, Rockwell can be seen getting the pose he wants from the dog, using his characteristic technique of a gentle push on the back of the head. The dog is not the focus of the painting; in fact, it is way up the hill, looking down at the women changing the tire on their automobile. To make the scene work, it was important to have the dog lazing about with its owner in contrast to the industrious young women, so Rockwell needed it to relax and put its head down.

 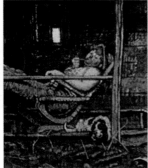

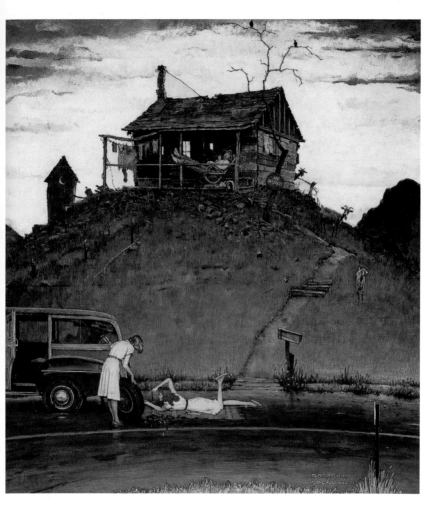

Fixing a Flat, cover of the *Saturday Evening Post*
(August 3, 1946). A dog lazes about with its
owner while two young women change a flat
tire. In the reference photo, Rockwell poses the
dog by pushing gently on the back of its head.

Mary and Norman Rockwell with
Butch outside the artist's studio in
West Arlington, Vermont.

Butch the Springer Spaniel

After Rockwell's first Vermont studio burned to
the ground, the Rockwell family moved to West
Arlington, next door to the Edgerton family and
their dairy farm. The dogs on the farm were working
dogs, expected to help bring in the cows, but two
of them, Shep and Spot, could often be found loung-
ing on the floor of Rockwell's studio or accompa-
nying the artist on his walks in the countryside.

The Rockwells had their own dog in West
Arlington, a black and white springer spaniel
named Butch. He was a friendly dog with very large
floppy ears. He modeled for the painting *Going
and Coming*, which depicts a family heading out
to the lake in one panel and returning after their
long day at the beach in a separate panel below.
Butch helps to tell the tale in these before-and-
after images. Like the young boy beside him, the
dog shows his exuberance at the start of the day,
his nose pointing forward into the wind and his
long ears flying behind him. But on the return trip,
his energy spent, Butch is much more relaxed, his
tongue hanging out as he stares blissfully out the
car's window, accompanying the family home.

Rockwell and Butch.

Rockwell greets one of his neighbor's
cows in West Arlington, Vermont, with
his springer spaniel Butch at his side.

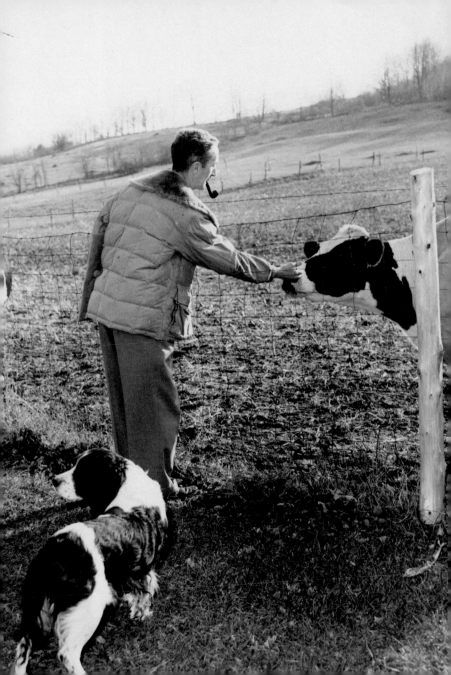

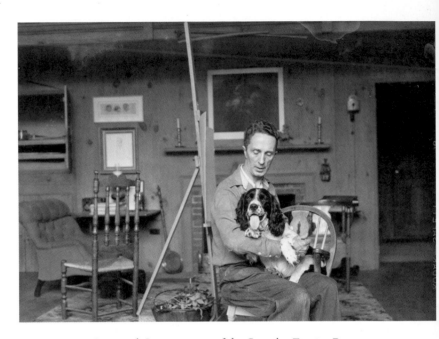

Going and Coming, cover of the *Saturday Evening Post*
(August 30, 1947). Rockwell used his own dog Butch
as a model for this famous *Post* cover. In the reference
photo, Butch poses on the artist's lap with his tongue
extended, as in the bottom frame of the painting.

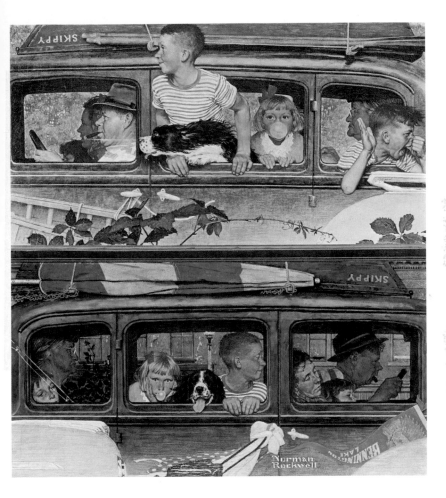

In October 1948, a little over a year after *Going and Coming* was featured on the cover of the *Post*, Butch disappeared from Rockwell's Arlington home. Dogs in the Vermont countryside were allowed to roam free, but it wasn't like Butch to stay away for too long. Rockwell walked several miles along the Batten Kill River calling for the dog. The police ended up rescuing the poor creature from a fox trap that had snared him in the woods. Rockwell was greatly relieved that Butch was not seriously injured. When a reporter from the *Bennington Banner* called Rockwell to ask how the dog was, the artist was happy to report that Butch was curled up at home with "a contented look" on his face, despite his injured paw.

 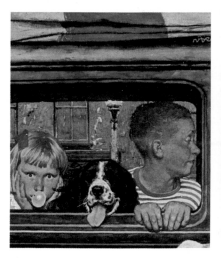

Dogs Help Tell the Story

The dogs in Rockwell's paintings were always part of the story the artist wanted to tell. "I do not like to see an appealing animal put into a picture just to save the job," explains the artist. "This trick does not fool anyone. I never include an animal in any picture unless it seems natural for it to be in the setting. But when you have a scene in which animals might be expected to appear, paint them well and put them in because people love to see them."

People certainly appreciated Rockwell's paintings of animals. He would often receive letters praising a dog he had painted and not necessarily making any comment on the humans in the same work.

Rockwell frequently used a dog to help express the emotion he was trying to convey in a painting, as in his depictions of soldiers coming home at the end of the Second World War. The exuberant welcome a family and the entire neighborhood extend to a returning veteran is reflected in a dog's ears, which fly back in enthusiasm as the pet rushes toward its long-missed companion. And when the serviceman is truly home and able to doze in his backyard hammock, with his dog happily snuggled on top of him, this time the ears are relaxed and at peace.

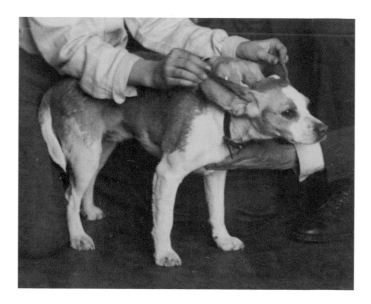

The Homecoming, cover of the *Saturday Evening Post*
(May 26, 1945). The whole neighborhood, including
the family dog, extends a warm welcome to a return-
ing World War II veteran in this *Post* cover, which hit
newsstands just eighteen days after Germany surren-
dered. In the reference photo, the dog posing with ears
held back is Spot, who belonged to Ardis Edgerton,
Rockwell's neighbor in West Arlington, Vermont.
Edgerton also modeled for this painting; she is the little
girl with the red hair and blue dress on the staircase.

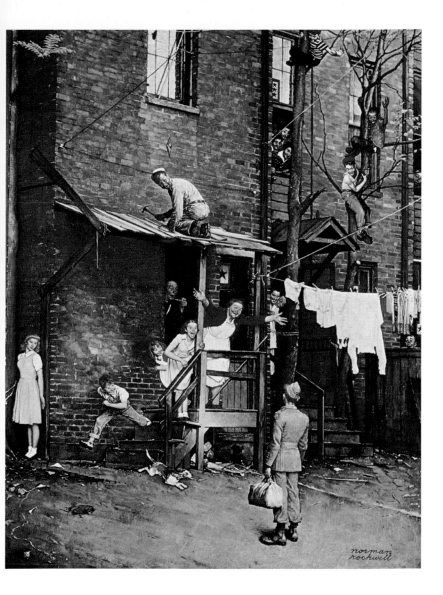

norman
rockwell

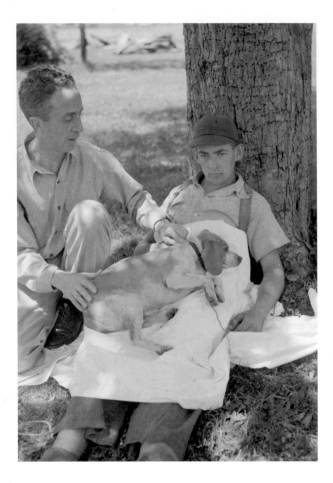

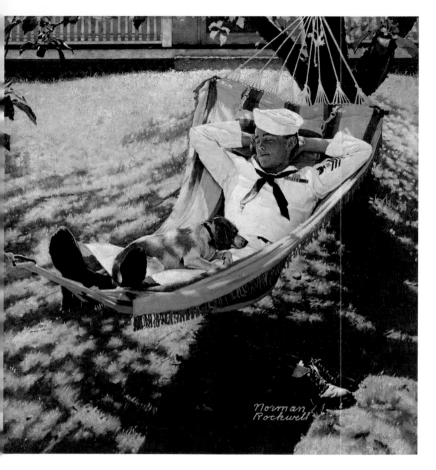

Home on Leave, cover of the *Saturday
Evening Post* (September 15, 1945). All is
at peace, even the beagle, which Rockwell
is seen posing in the reference photo.

Sometimes Rockwell would use a dog as the focal point of the narrative. This is the case with *Roadblock*, a 1949 *Post* cover in which a small but determined bulldog blocks a huge moving truck in an alley. All the characters in the painting have stopped to look at the dog, with some pointing directly at him. Rockwell directs every line in the painting to the center of interest, creating a circle around the dog and ensuring the viewer has no doubt who is responsible for the blockage. Rockwell composed this painting in Los Angeles. The bulldog at the center of the whole scene belonged to a man Rockwell had met in a park not far from the alley. The dog's owner was asked to pose on the porch above, in an undershirt, with his pipe pointing down toward his own dog who was the center of all the action.

Where the dog is not the focal point, it frequently points toward the action, like the fluffy Pekingese who watches the two plumbers try out her mistress's perfume in a 1951 *Post* cover. Rockwell used the well-groomed Pekingese, wearing a wide pink bow, to exaggerate the feminine atmosphere of the room in contrast to the two plumbers in overalls holding

Roadblock, cover of the *Saturday Evening Post* (July 9, 1949). The owner of the bulldog who modeled for this painting is himself depicted at top right, leaning over a railing in his undershirt.

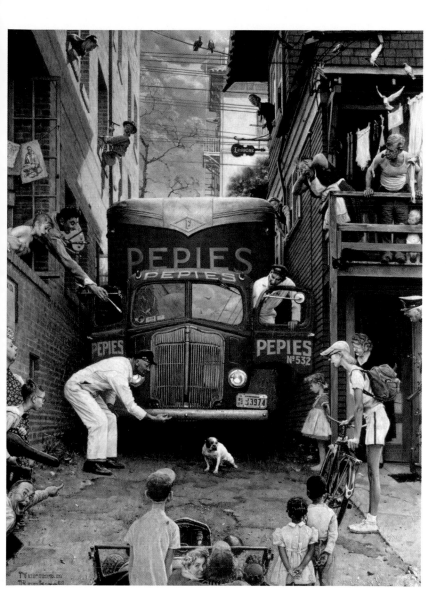

Two Plumbers, cover of the *Saturday Evening Post* (June 2, 1951). In the first photo, Rockwell is seen working with the dog handler to get the Pekingese's pose just right. He then had his photographer make an enlargement of the Pekingese to serve as a reference for the painting. The enlargement conveys the intensity of the Pekingese's eyes, which help direct the viewer to the two plumbers in the finished work.

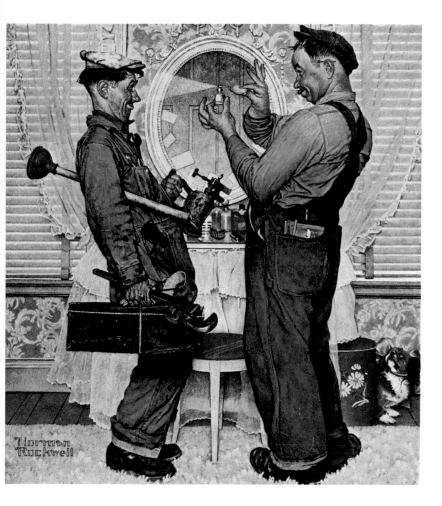

their wrench and plunger. The male workers pre-
sumably have a very different scent than the perfume
coming out of the delicate bottle! One can't help
but think that the Pekingese doesn't approve of the
plumbers fooling around in her mistress's boudoir.

Rockwell would use a Pekingese again as a model
the following year. This time it is joined by a large
assortment of dogs of various shapes and sizes,
all directing their attention and compassion to
the sweet young boy holding a puppy with a ban-
daged head on his lap in the center of a veterinari-
an's clinic. The boy's puppy was said to be inspired
by a two-month-old brown and white dog called
Rags. Rockwell found him at the Humane Society
of Missouri in St. Louis, where he spent an after-
noon sketching out his ideas for the painting. Four
of the other dogs that Rockwell sketched and pho-
tographed at the St. Louis clinic were pets who
belonged to friends of the president of the Humane
Society. The local newspaper, the *St. Louis Globe
Democrat*, was happy to report that Rags, who
became a St. Louis celebrity thanks to the *Post* cover,
was adopted soon after Rockwell sketched him.

Another example of the dog as observer, help-
ing direct the viewer toward the action, is the

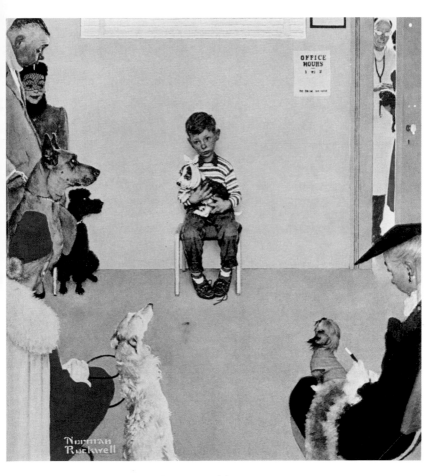

Boy in Veterinarian's Office, cover of the
Saturday Evening Post (March 29, 1952).

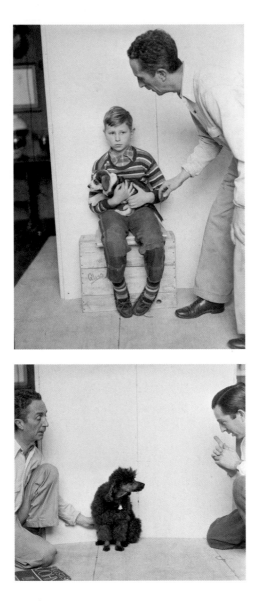

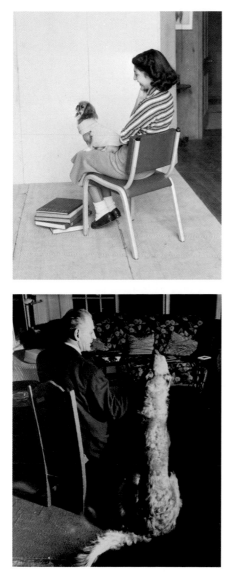

Some of the numerous reference photos for *Boy in Veterinarian's Office. Opposite top*, Rockwell encourages both the boy and the puppy to relax into the pose. *Opposite bottom*, the handler coaxes the poodle to sit and be good while the artist directs the pose. *Top*, the Pekingese sits at attention on a woman's lap. *Bottom*, the elegant borzoi poses.

black cocker spaniel in *Soda Jerk*, which appeared on the cover of the *Post* on August 22, 1953. This painting is centered on the intense gaze shared between the soda jerk and his female customer. Everyone is looking at the young couple, including the spaniel, but this time we don't see the dog's eyes at all. Seated at the soda fountain on a swivel stool, the cocker spaniel has his back to us, his entire black body pointing like an arrow toward the young couple, and toward the unfinished milkshakes that sit ignored on the counter.

During the fall of 1953, the Rockwells would leave their home in Arlington, Vermont, to move

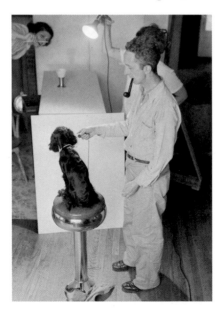

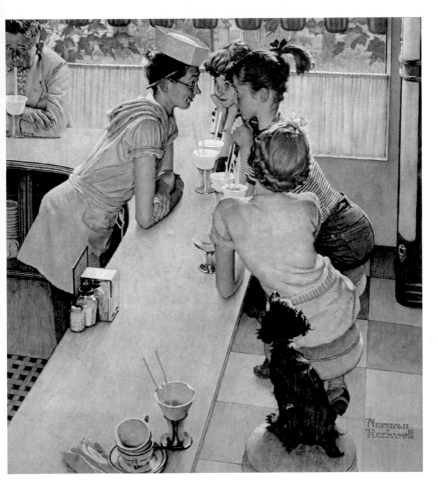

Soda Jerk, cover of the *Saturday Evening Post* (August 22, 1953).
Rockwell's son Peter posed as the soda jerk. Peter's girlfriend, Cinny,
whom he would later marry, posed for the painting as well—but only
her bottom made it into the finished work. In the reference photo, the
black cocker spaniel looks intently at the straw held by the woman,
while the artist makes sure the dog's body is perfectly positioned.

to Stockbridge, Massachusetts. Norman Rockwell had started to paint the very moving *Breaking Home Ties* in Arlington but would finish it in his first Stockbridge studio, on Main Street. In this painting, the dog's sorrowful eyes are clearly visible and help express the emotion it shares with the rancher, who is preparing to say goodbye to his son as they wait for the train that will take the boy away from home to attend college. The hunched-over father looks dejected, ignoring his son's enthusiasm for the journey ahead, while the beautiful

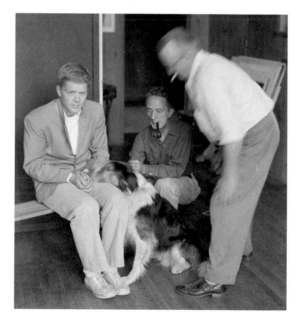

Breaking Home Ties, cover of the *Saturday Evening Post* (September 25, 1954). This painting, considered one of Rockwell's masterpieces, was so beloved by Don Trachte, its owner, that he hid it in a wall for years and painted a replica for display. (Trachte's sons discovered the original in 2006.) In the reference photo, Rockwell gets the collie to pose with its head resting on his son Tom's knee.

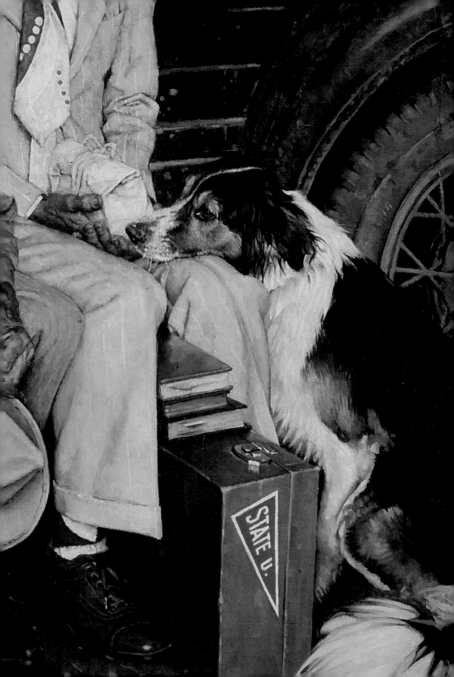

collie rests its head on the boy's lap, trying to keep its connection with him as long as it possibly can. "I got most of my fan letters about the dog," said Rockwell. "You see the father couldn't show how he felt about the boy's leaving. The dog did."

The sorrowful collie was the last dog to appear in a Rockwell *Post* cover, although the artist would contribute covers to the magazine for another nine years. Upon leaving the *Post*, Rockwell would paint his very important civil rights paintings for *Look* magazine, and in one of them a dog would help convey a message of hope. In *New Kids in the Neighborhood*, Rockwell used a sweet dark dog to contrast with the fluffy white cat held by the new little girl moving into the suburban house. Rockwell showed how the children, and their pets, were interested in each other, and would more than likely end up playing together, bringing hope to a racially divided America.

In addition to painting purebreds, mutts, strays, and his own dogs, Rockwell painted famous dogs. He painted Terry the Terrier, who appeared with Judy Garland as Toto in the *Wizard of Oz*. Both the dog and Judy Garland had passed away before the Singer Sewing Company

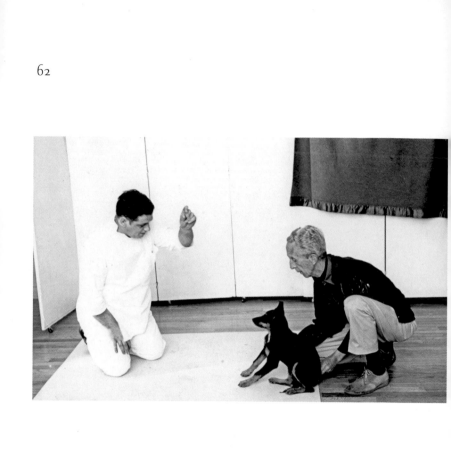

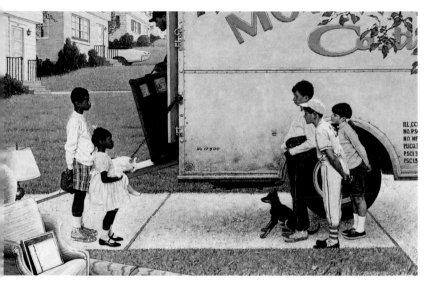

New Kids in the Neighborhood, illustration for
Look magazine (May 16, 1967). This paint-
ing illustrated an article about integration in
Park Forest, a suburb of Chicago. In the refer-
ence photo, Rockwell adjusts the pose of the
German shepherd puppy.

commissioned Rockwell in 1969 to paint the dog in Dorothy's arms, just as they appeared in their publicity shot from the movie's debut in 1939.

Not all of Rockwell's ideas for paintings were successes, even when he had a celebrity dog to pose for him. Around 1960, the artist was in Los Angeles, and Twentieth Century–Fox provided him with movie stars to pose as models for a *Post* cover he was working on that would be a parody of an English murder mystery. The studio arranged for Ethel Barrymore, Loretta Young, Richard Widmark, Boris Karloff, Van Johnson, Linda Darnell, Clifton Webb, and the TV star Lassie the dog to pose for him. The composition drawing didn't work out, and Rockwell ended up not executing the final painting, although he did take reference photos of the famous Lassie and did some sketches of the beautiful collie before abandoning the work.

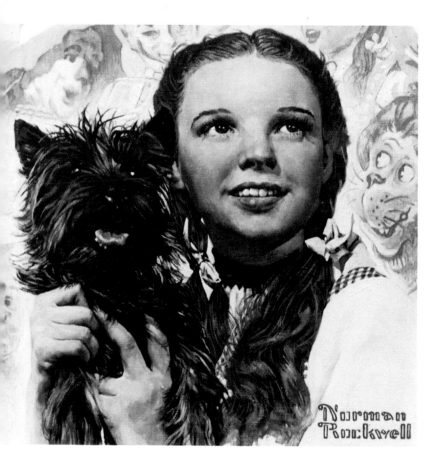

Judy Garland as Dorothy in "The Wizard of Oz,"
1969–70. After Judy Garland's death, the Singer
Sewing Company commissioned Rockwell to
depict the actress in her most iconic role. This
painting was used to promote a television broad-
cast of *The Wizard of Oz* sponsored by Singer.

66

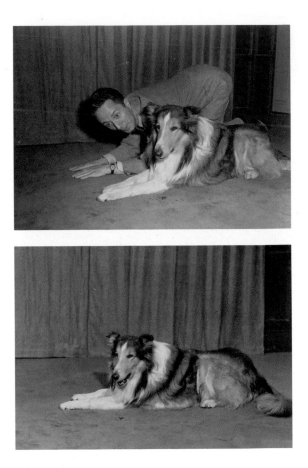

Murder Mystery, c. 1960. This is Rockwell's full-size composition drawing for an abandoned *Post* cover that was supposed to present all the clues necessary to solve a murder mystery. Rockwell found his models in Hollywood: Van Johnson is the dead man; Loretta Young, the maid; Ethel Barrymore, the lady

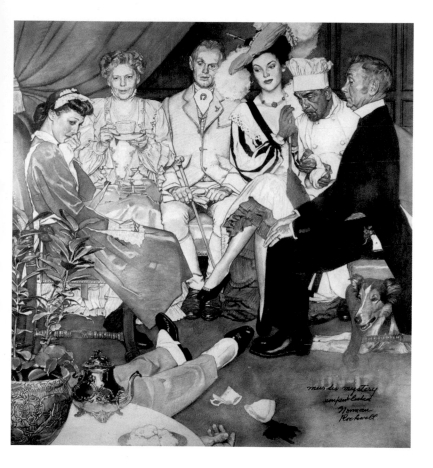

of the manor; Richard Widmark, the disreputable gentleman; Linda Darnell, the glamorous actress; Boris Karloff, the chef; and Clifton Webb, the butler. The dog is none other than the famous Lassie, seen here in a photo with Rockwell and posing solo in another shot that the artist used as a reference for *Murder Mystery*.

Later Years with Pitter and Sid

After his wife Mary died in 1959, Rockwell was alone in his Stockbridge home. His daughter-in-law Gail, Tom's wife, found Pitter, a beagle mix, in Pittsfield's rescue shelter. She thought her father-in-law needed a dog and Pitter needed an owner, so she brought the dog to Stockbridge. Named after his home-town, Pitter provided companionship to the wid-ower and modeled for his paintings and drawings.

Rockwell at work in his Stockbridge studio, with Pitter relaxing nearby.

Rockwell leaving his studio on South Street, Stockbridge, with Pitter the beagle mix.

In 1961, Rockwell married Molly Punderson. The year after their wedding, Pitter would be featured on Molly and Norman Rockwell's Christmas card, which shows them out for a walk, Pitter's ear and Molly's scarf blowing in the wind as they all stride forward. Rockwell used Pitter as a model for *Juvenile Cowboy* in 1960 and for the Boy Scout calendar painting in 1964. He would also use a reference photo of his old dog when composing *Home from Camp* in 1968, long after Pitter's death in 1964.

Detail of *Juvenile Cowboy*, 1960. Rockwell included this very fine drawing of Pitter in an advertisement for the Massachusetts Mutual Life Insurance Company.

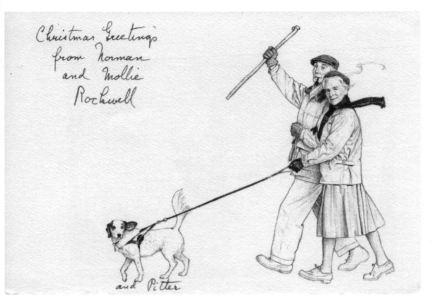

Christmas Greetings
from Norman
and Mollie
Rockwell

and Pitter

Rockwell drew his wife Molly, his dog
Pitter, and himself for a Christmas
card the couple sent out to friends and
family in 1962.

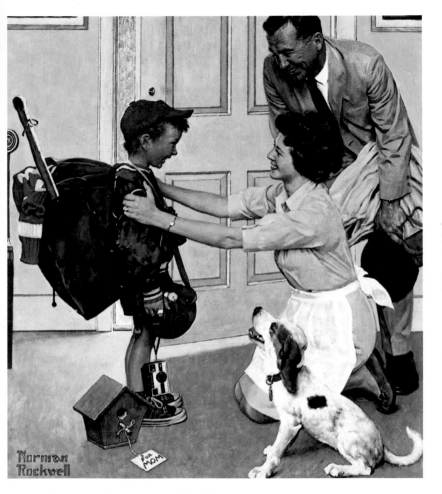

Home from Camp, cover of Top Value
stamps catalog, 1968. Rockwell
painted the dog from this reference
photo of Pitter, who had died in 1964.

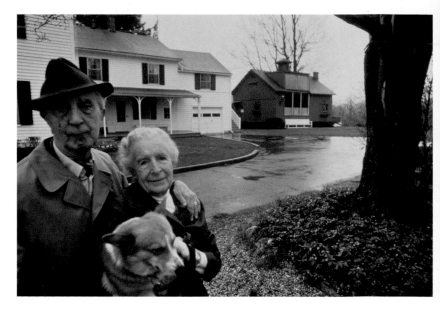

Norman and Molly Rockwell with
their corgi Sid, in front of their
home in Stockbridge. The artist's
studio is to the right.

After Pitter, a new puppy, a corgi named Sid, entered the Rockwell household. Sid wouldn't appear in any paintings, but he would alert the elderly couple by barking whenever the phone rang, and he wouldn't let up until it was answered.

Norman Rockwell worked on one particular painting from 1972 to 1976, while he struggled with emphysema and dementia toward the end of his long career. The painting depicts a scene from the town of Stockbridge's own history when Chief Konkapot met with the colonial missionary Reverend John Sergeant. At first Norman Rockwell painted the scene without a dog, but he would later add one as a witness to the meeting. When Rockwell died in November 1978, the painting was still not finished and had not received his signature. He may not have been satisfied with the painting, nor with how he had painted the beagle, but this dog still plays a role in the work. Its eyes help direct the viewer to the focal point of the painting. The dog points toward the message Rockwell wanted to convey, just as so many of the artist's dogs had done before.

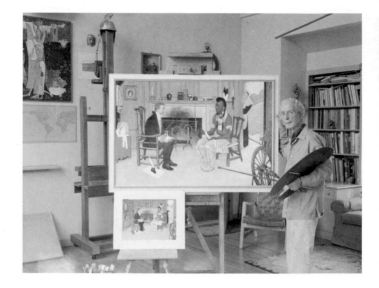

Rockwell had a lifelong association with dogs. They were his models and often his muses. He drew and painted them throughout his successful career. His dogs appeared on magazine covers and were beloved by his audience. Dogs were also his loyal companions in the studio, at home, and when they went out together for long, enjoyable walks. Norman Rockwell and his many, many dogs were faithful friends, until the very end.

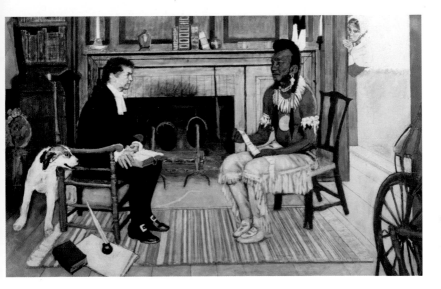

John Sergeant and Chief Konkapot, 1972–76.
This painting remained unsigned and unfin-
ished at Rockwell's death in 1978. A photo-
graph shows the artist with an earlier
version of the work, before he added the
dog to the scene.

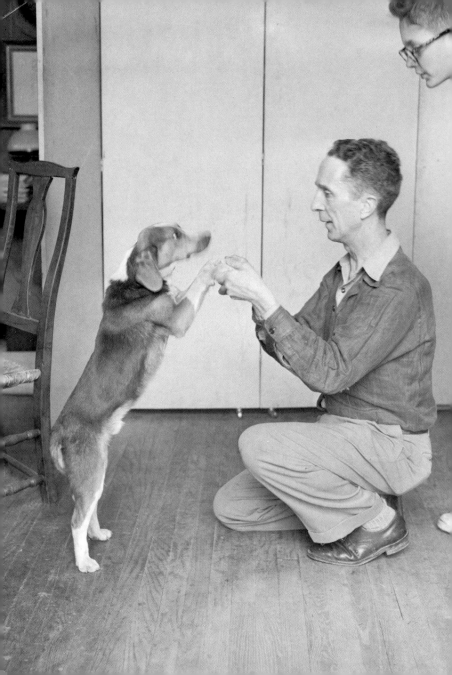

A Gallery of
Rockwell Dogs

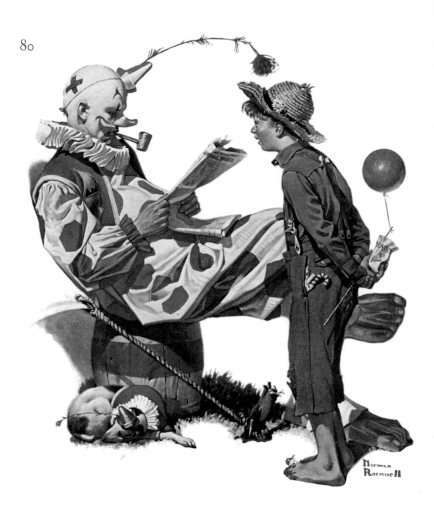

Clown and Boy, cover of the *Saturday Evening Post* (May 18, 1918). A boy comes across a clown relaxing with a pipe and a newspaper while his dog, wearing a ruffle and matching hat, sleeps. This exhausted circus performer was the first of Rockwell's dogs to appear on the cover of the *Post*.

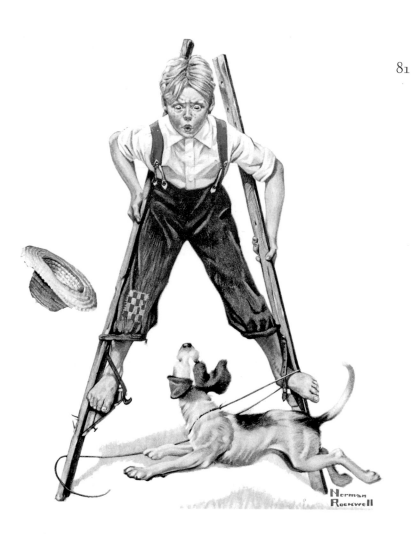

Boy on Stilts, cover of the *Saturday Evening Post* (October 4, 1919). This enthusiastic spotted dog is making things very difficult for the barefoot boy on stilts.

Four Boys on a Sled, cover of *Country Gentleman* (December 27, 1919). Here is the dog with a black patch over its eye that Rockwell painted so often in his early career.

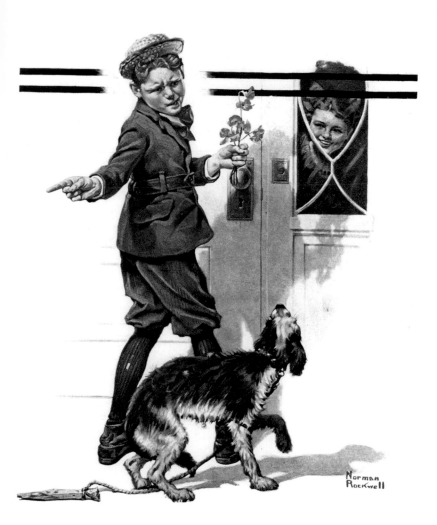

Boy Sending Dog Home, cover of the *Saturday Evening Post* (June 19, 1920). His devoted dog is banished when the boy has romance on his mind.

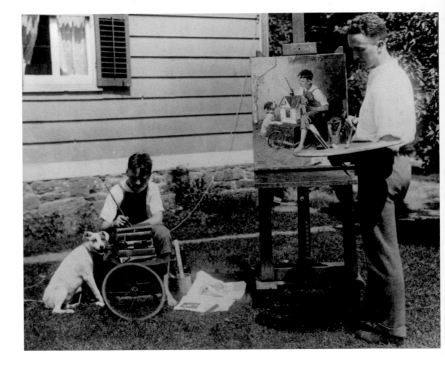

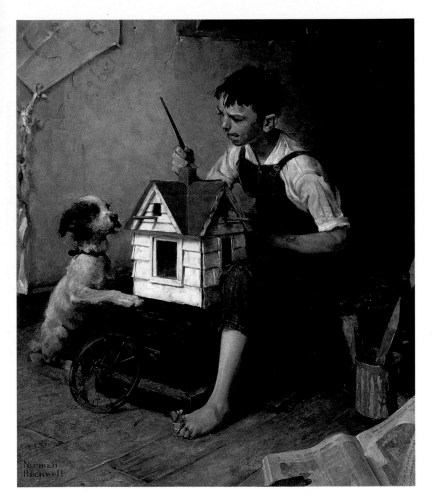

Painting the Little House, advertisement for the Save
the Surface Campaign, 1921. Rockwell's mod-
els for this advertisement, which appeared in the
Saturday Evening Post, were Franklin Lischke and
his dog. Here they pose for a photograph with
Rockwell outside the artist's New Rochelle studio.

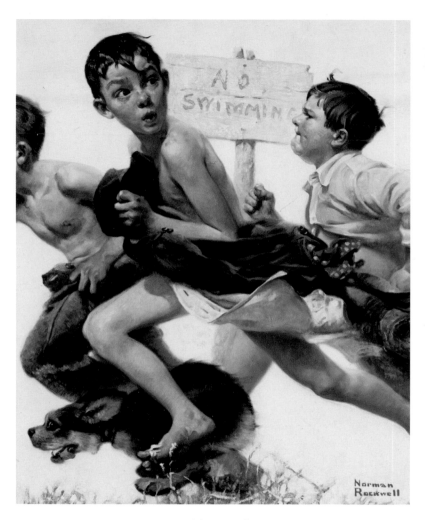

No Swimming, cover of the *Saturday Evening Post*
(June 4, 1921). The dog knows they shouldn't have
been swimming. His tail is between his legs and
his tongue and ears are flapping as he makes his
escape with the boys.

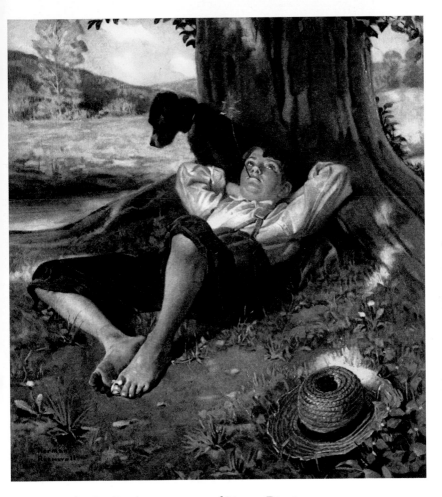

Barefoot Boy Daydreaming, cover of *Literary Digest* (July 29, 1922). This painting was reused on the June 1946 issue of *Grade Teacher*, evidently to herald the arrival of summer vacation.

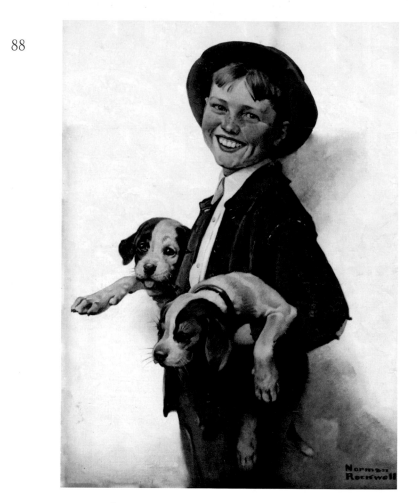

Boy with Puppies, cover of *Country Gentleman* (March 18, 1922). One puppy has the characteristic black patch over one eye; the other has patches over both.

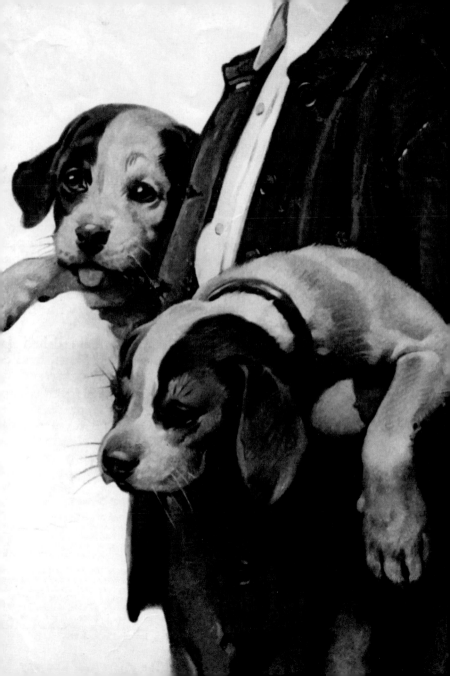

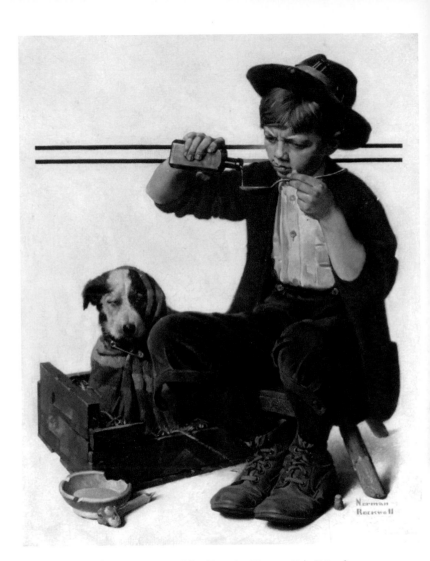

Sick Puppy, cover of the *Saturday Evening Post* (March 10, 1923). The boy pours some medicine onto a spoon for the little dog, who clearly isn't feeling very well.

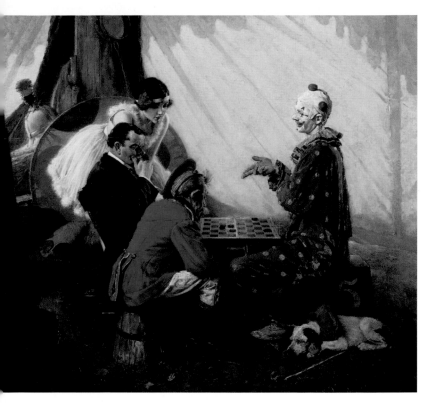

Checkers, illustration for *Ladies' Home Journal*
(signed 1928, published July 1929). Exhausted from
his circus act, the little black-and-white dog with a
red ruffle around his neck sleeps beside the clown,
who plays checkers with the other performers.

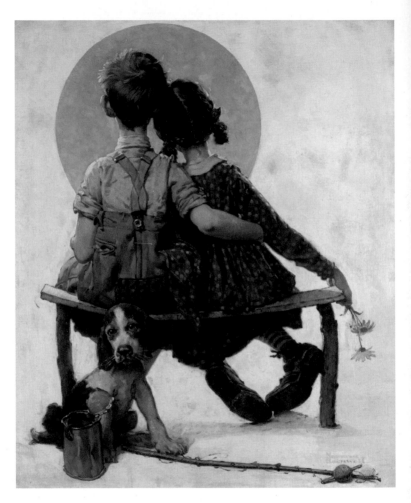

Boy and Girl Gazing at Moon, cover of the *Saturday Evening Post* (April 24, 1926). This painting is sometimes also titled *Puppy Love*—but the puppy is forgotten, along with the fishing gear, when the boy has a chance to gaze at the moon with a sweetheart.

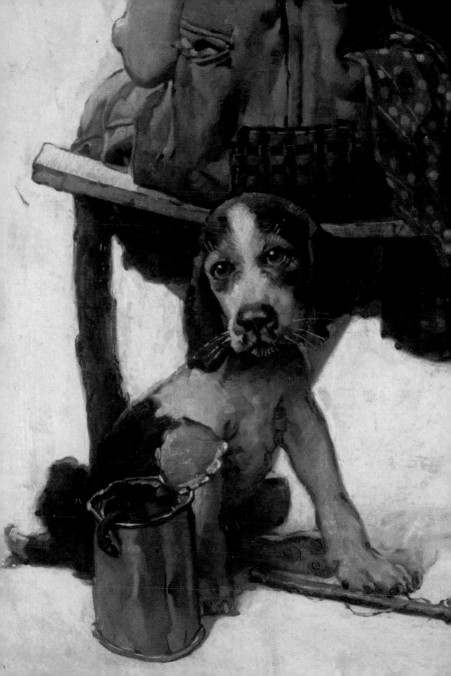

Heading for chapter 10 of *The Adventures of Tom Sawyer*, "Dire Prophecy of the Howling Dog" (1936); heading for chapter 16 of *The Adventures of Huckleberry Finn*, "The Rattlesnake Skin Does Its Work" (1940). Rockwell's illustrations for these Mark Twain classics include two free and energetic drawings of dogs.

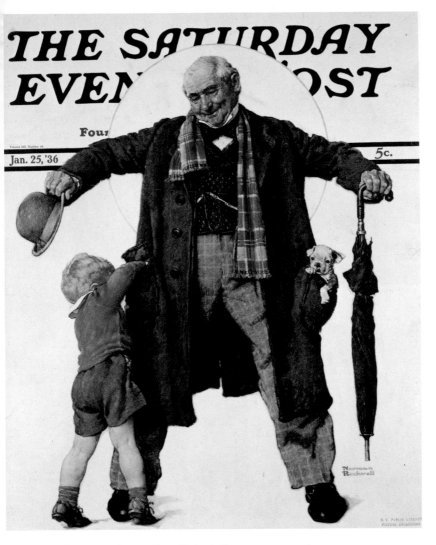

Little Boy Reaching in Grandfather's Overcoat, cover of
the *Saturday Evening Post* (January 25, 1936). Rockwell's
two-year-old son Tom posed for this painting.

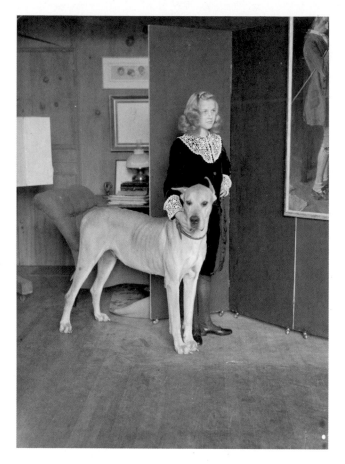

Little Lord Fauntleroy, c. 1945. This painting was part of an unpublished series illustrating characters from American literature. In the reference photo, the huge Great Dane poses beside the young model in Rockwell's West Arlington, Vermont, studio.

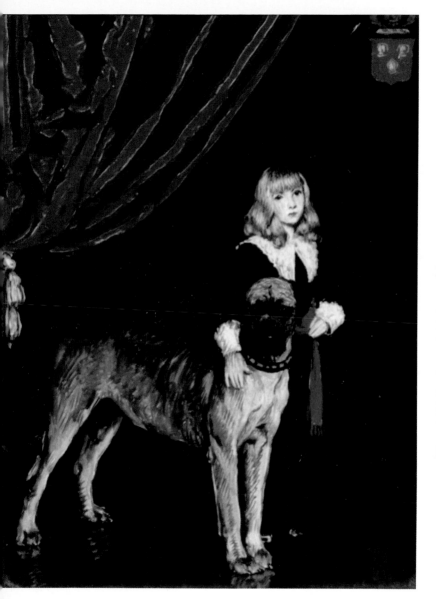

Norman Rockwell Visits a Family Doctor, illustration for the *Saturday Evening Post* (April 12, 1947). In this painting, part of a series examining country life, the dog waits quietly on the rocking chair next to the fire while the doctor talks with the family about the child's health. The canine model was a spaniel named Bozo who lived in Arlington, Vermont, with his owner, Dr. Russell.

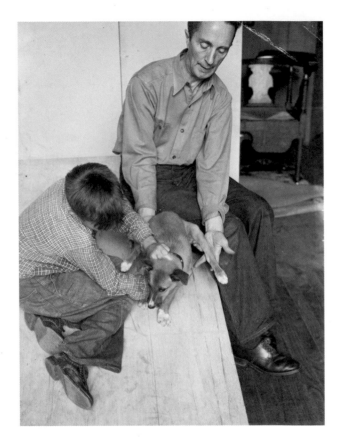

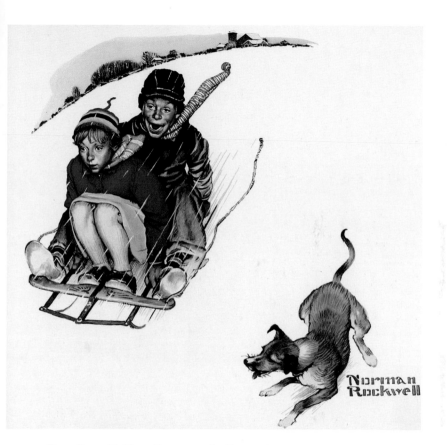

Young Love: Sledding, illustration for Brown &
Bigelow's 1949 *Four Seasons* calendar. To get the
dog's pose just right, Rockwell had some help
from a young friend in his West Arlington studio.

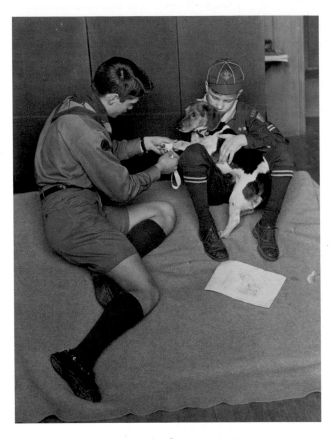

Friend in Need, illustration for the 1949 Boy Scouts of America calendar. The reference photo, taken in Rockwell's West Arlington studio, is a remarkably complete staging of the final scene.

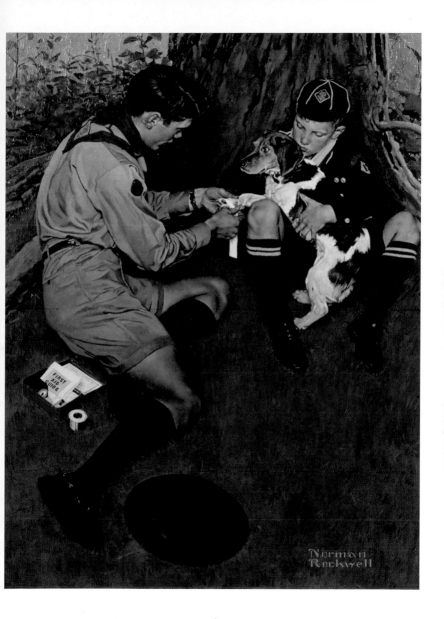

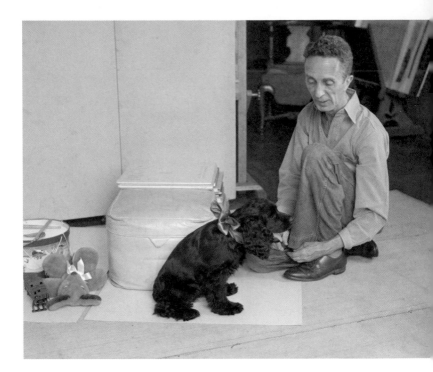

Enchanted Lands . . . Right in Your Home, advertisement for the DuMont Television Network, 1950. The children and their dog are transfixed by the new attractions on the television screen while their toys remain ignored behind them. In the reference photo, Rockwell poses the sweet black cocker spaniel with a bow around its neck.

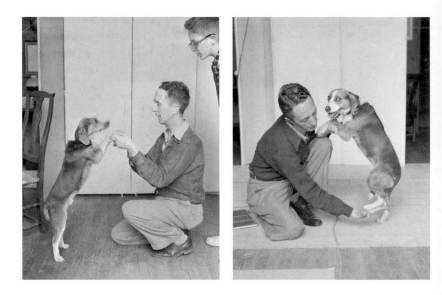

Christmas Dance, illustration for a Hallmark Christmas card, 1950. Rockwell's youngest son, Peter, looks on as the artist convinces his canine model to dance. The dog lifts his foot for the artist but seems a little embarrassed by the situation.

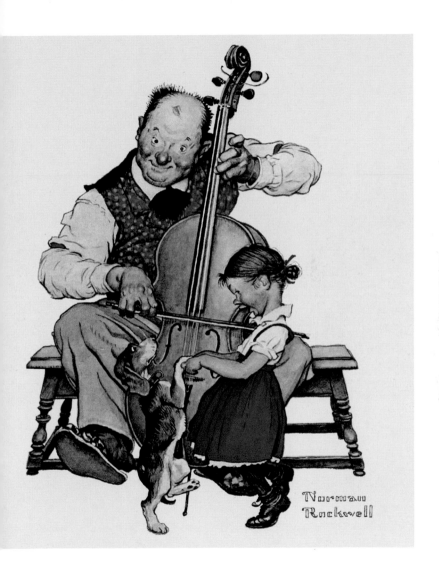

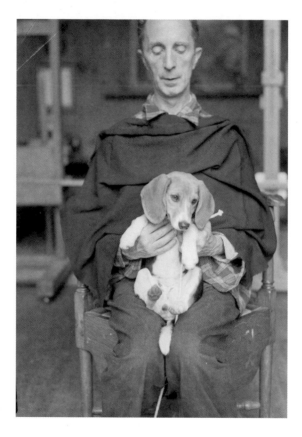

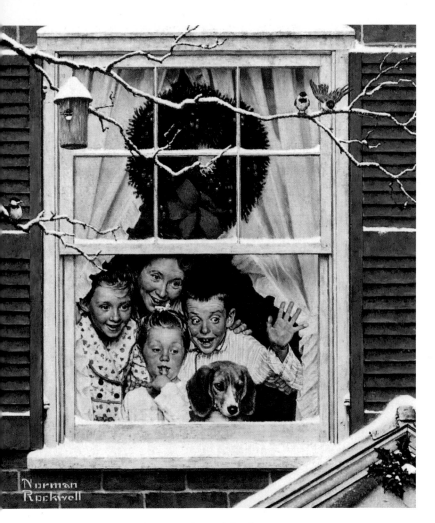

"Oh, Boy! It's Pop with a New Plymouth!", adver-
tisement for Plymouth automobiles, 1951. In the
reference photo, Rockwell has draped himself
with a dark cloth so that the adorable face of the
beagle will stand out clearly in the photograph.

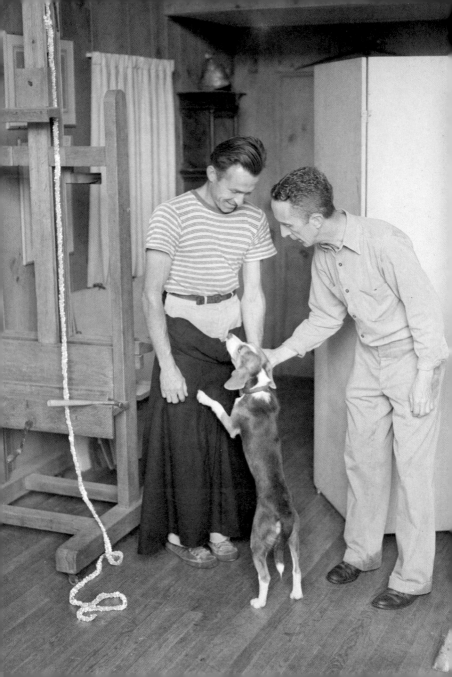

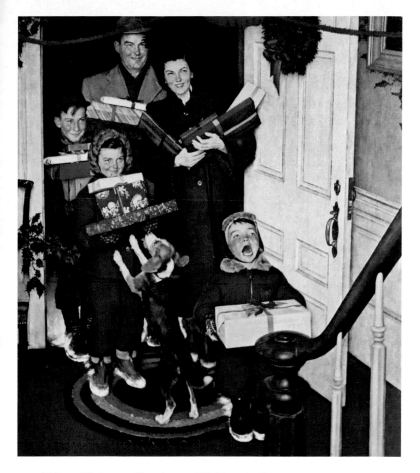

"Merry Christmas, Grandma . . . We Came in Our New Plymouth!", advertisement for Plymouth automobiles, 1951. Rockwell encourages his canine model to jump up on his assistant Louie Lamone, who wears a black skirt to help outline the dog's form. In the final painting, Rockwell added a little more lift to the dog's right ear.

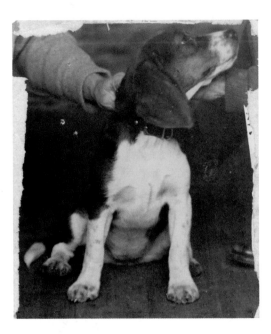

First Day of School, advertisement for Sears clothing, 1964. Rockwell used his reference photographs of this beagle for multiple works, including this advertisement, the one on the next spread, and his unfinished canvas *John Sergeant and Chief Konkapot* (see page 77).

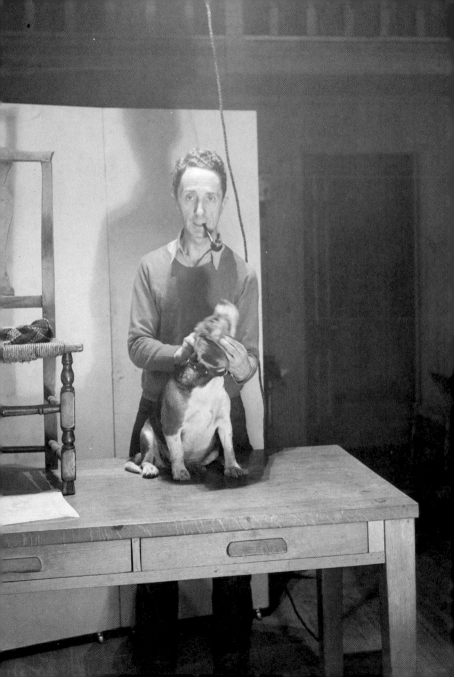

The Music Man, cover of Top
Value Stamps catalog, 1966.

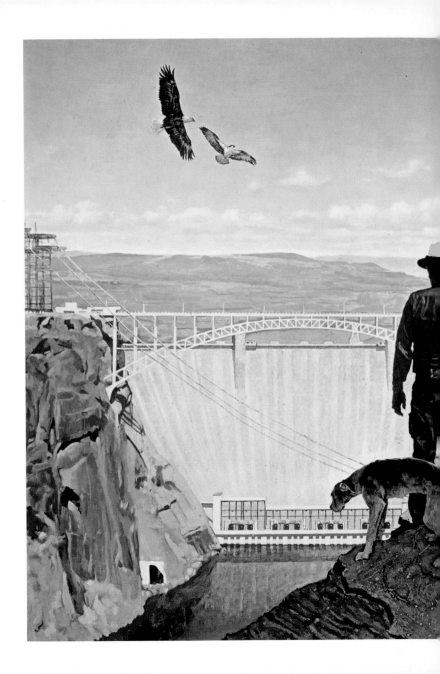

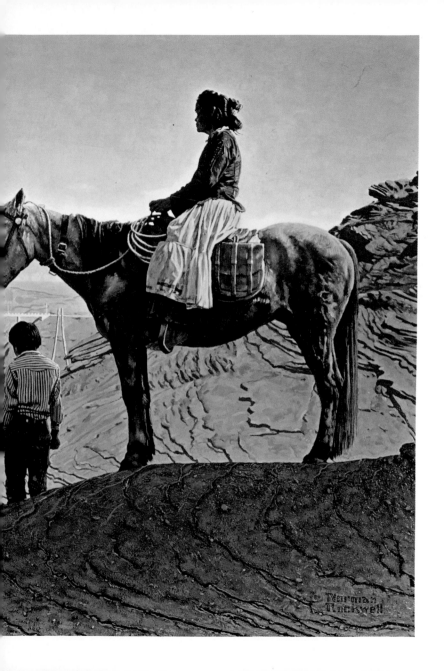

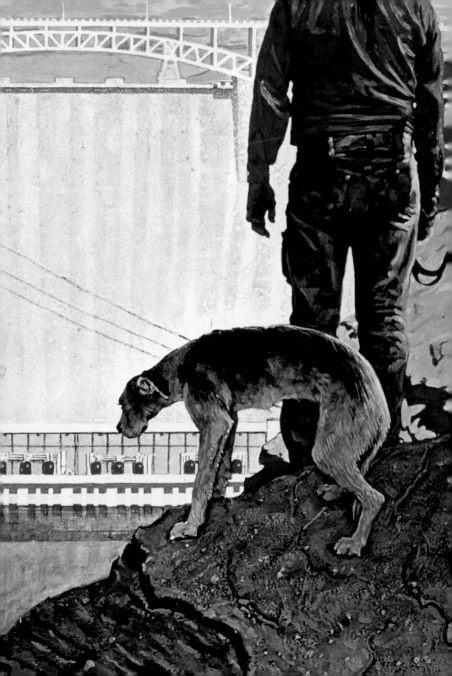

Glen Canyon Dam, 1969. This painting was commissioned by the Department of the Interior, which had recently constructed this massive hydroelectric dam in northern Arizona, on the Colorado River. (The dam's reservoir flooded its namesake canyon, causing an outcry among environmentalists.) Rockwell and his wife Molly visited the dam and photographed the Navajo family in a nearby Arizona town, but the dog was photographed in Stockbridge.

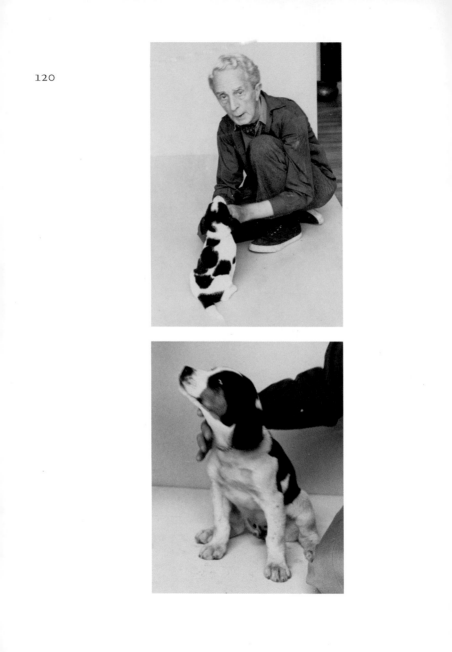

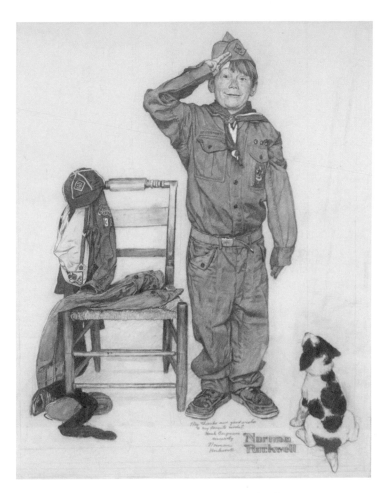

Charcoal drawing for *Can't Wait*, illustration for the
1972 Boy Scouts of America calendar. In this pre-
liminary study, Rockwell depicted the dog's back
and cute white-tipped tail, as in the first reference
photo seen here; in the final work, he would show
the pup from the front, as in the second photo.

Acknowledgments

The reference photographs included in this book were used by Norman Rockwell when he painted at the easel. Rockwell usually staged the photos himself while a hired photographer operated the camera. Most of the photographs were taken by Gene Pelham in Arlington, Vermont, and Bill Scovill and Louie Lamone in Stockbridge, Massachusetts. The professional photographer Clemens Kalischer also took a few photos of Norman Rockwell with dogs, one of which is reproduced in this book.

Rockwell's reference photos, formerly stored in his studio, are now kept at the Norman Rockwell Museum in Stockbridge, Massachusetts. The museum's deputy director and chief curator, Stephanie Haboush Plunkett, reviewed the manuscript for this book and provided helpful comments. The museum's archivist, Venus Van Ness, helped find the photographs and some of the paintings for reproduction in the book. The preservation of Rockwell's reference photographs is very important to understanding the artist and his process. I am very grateful for all that the Museum does to preserve Norman Rockwell's legacy.

I'd also like to thank Jarvis and Tom Rockwell for sharing their memories of their father and the dogs in his life.

Page numbers in *italics* refer to illustrations.

Image Credits

Images are courtesy of the Norman Rockwell Family Agency, with the exception of the following:

Abbeville Press archives: pp. 6, 25, 29, 41, 42, 45, 51, 53, 80, 81, 83
© the Estate of Clemens Kalischer: p. 128
Norman Rockwell Museum, Stockbridge, Massachusetts: pp. 2, 9, 12, 16, 24, 26, 28, 32, 34 left, 38–40, 44, 46, 60, 54–56, 58, 62, 65, 66, 68, 69, 70, 71, 72, 76–78, 96, 100, 102, 104, 105, 106, 108, 110, 112, 114, 119, 120

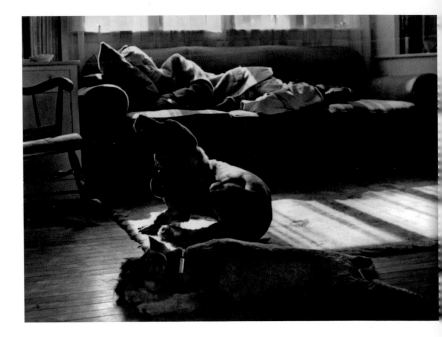